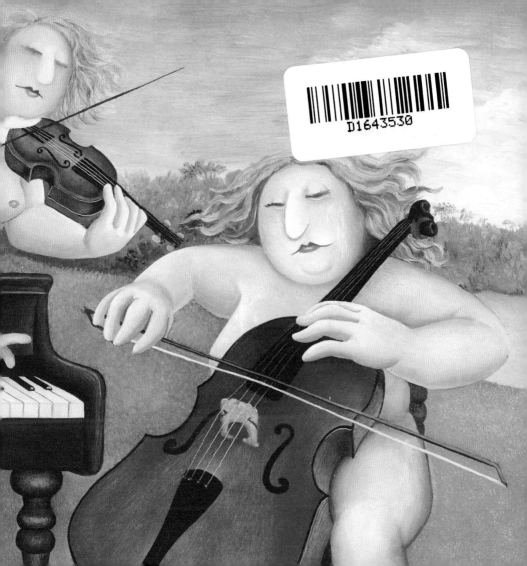

30 CAKES TO EAT NAKED

WITH ILLUSTRATIONS BY BERYL COOK

kinkajou

1
VICTORIA
SPONGE

2
RED VELVET

3
MOIST PLUM

4
LEMON DRIZZLE

5
COFFEE &
WALNUT

6
CARROT

7
CHOCOLATE
ESPRESSO

8
PINEAPPLE
UPSIDE-DOWN

9
LEMON
POLENTA

10
LAVENDER &
HONEY

11
EASY
CHOCOLATE

12
APPLE

13
CHOCOLATE
ÉCLAIRS

14
SAUCY SCONES

15
TRIPLE
CHOCOLATE
BROWNIES

16
APRICOT & WHITE
CHOCOLATE
FLAPJACKS

17
MACAROONS

18
MAPLE SYRUP
& BACON
CUPCAKES

19
DEVIL'S FOOD
CUPCAKES

20
CHOCOLATE
ORANGE
CUPCAKES

21
GINGERBREAD
CUPCAKES

22
STRAWBERRIES
& CREAM
CUPCAKES

23
GOOSEBERRY
CUPCAKES

24
BLACK FOREST
CUPCAKES

25
RHUBARB &
CUSTARD TART

26
CHOCOLATE TART

27
LEMON TART

28
SUMMER FRUITS
TART

29
BLUEBERRY TART

30
CHOCOLATE &
PEANUT BUTTER
TART

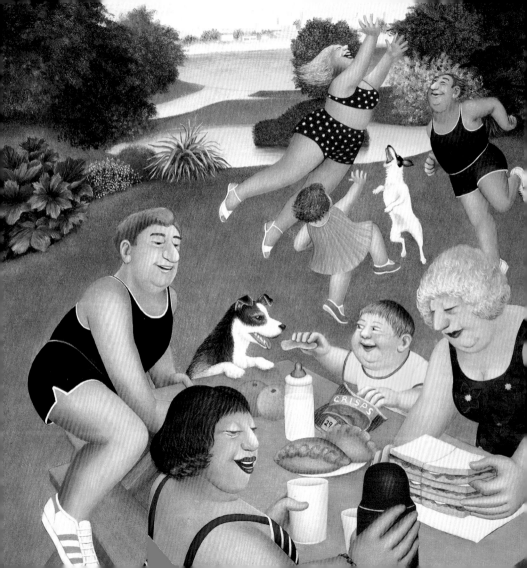

Victoria Sponge

CAKE

- 225g (8oz) self-raising flour • 225g butter (8oz), at room temperature
- 225g (8oz) caster sugar • 4 eggs • 1 tsp baking powder
- Raspberry or strawberry jam • Whipped double cream •

1. Preheat your oven to 180°C/350°F/Gas Mark 4. Excluding the jam and cream, mix all the ingredients together in one bowl until thoroughly combined.
2. Pour the mixture into two non-stick 7 inch (18cm) tins and bake them in the oven for 20–25 minutes, or until a toothpick will come out clean if inserted into the centre. Remove the cakes from the oven and leave to cool.
3. When cooled, spread a solid covering of jam to the base of one cake and cream to the top of the other. Sandwich together and serve with a dusting of icing sugar.

Red Velvet Cake

CAKE

- 160g (5¼oz) butter • 400g (15oz) caster sugar • 3 eggs • 50g (1¾oz) cocoa powder
- 2 tbsp red food colouring gel • 2 tsp vanilla extract • 400g (15oz) plain white flour • 1 tsp salt
- 320ml (11fl oz) buttermilk • 1½ tbsp white wine vinegar • 1 tsp bicarbonate of soda •

ICING

- 100g (3½oz) butter • 600g (21oz) icing sugar • 250g (9oz) cream cheese (full fat) •

1. Preheat your oven to 180°C/350°F/Gas Mark 4, and line three 8 inch (20cm) tins.
2. Cream the butter and sugar together in a large mixing bowl until light and fluffy. Add the eggs one at a time and then add the cocoa powder and the vanilla extract.
3. Sift the flour into a separate bowl and add the salt. Start adding the flour and the buttermilk alternately and a bit at a time. When thoroughly combined, add the red gel, stirring until the colour is evenly incorporated.
4. In a small mug, combine the white wine vinegar and the bicarbonate of soda and then stir it into the mixture.
5. Pour the mixture into the three lined tins and bake for 25–30 minutes, or until a toothpick will come out clean if inserted into the centre.
6. Place all of the the ingredients for the icing into a bowl and beat until beautifully creamy. Spread the sumptous mixture between each of the layers and then over the top and sides of the assembled cake. Serve in luxurious large slices.

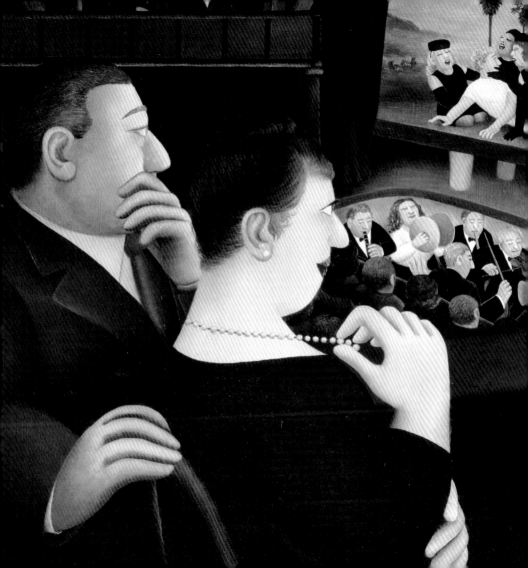

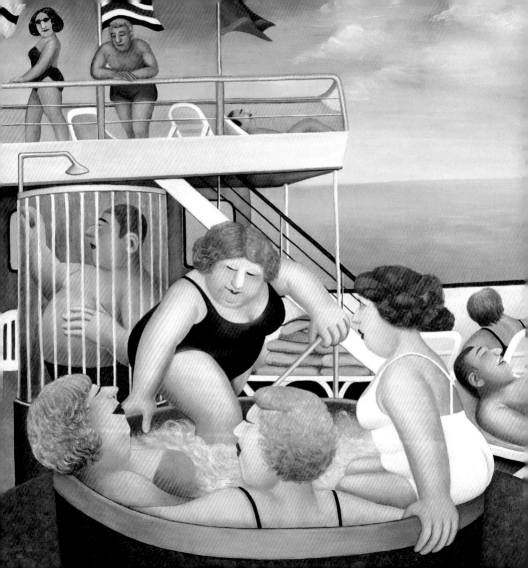

Moist Plum Cake

CAKE

• 150g (4¾oz) caster sugar • 115g (4oz) soft butter • 140g (5oz) plain flour • 1 tsp baking powder
• 2 eggs • 1 pinch salt • 12 plums, pitted and halved • 1 tsp ground cinnamon
• 1–2 tbsp caster sugar, for sprinkling •

1. Preheat your oven to 180°C/350°F/Gas Mark 4.
2. Beat the sugar and butter together until fluffy, and then sift the flour and baking powder into the mixture and combine. Beat in the eggs and salt.
3. Pour the cake mixture into a greased 10 inch (26cm) round tin. Ensure the top is level, then place the plums cut side up on the top in any pattern you choose. Sprinkle with the extra sugar and the cinnamon.
4. Bake on lowest shelf for 40–50 minutes or until a toothpick will come out clean if inserted into the centre.
5. Serve warm or leave to cool, if you can resist temptation.

Lemon Drizzle Cake

CAKE

• 1½ large eggs • 87.5g (3oz) self-raising flour • 87.5g (3oz) caster sugar
• 87.5g (3oz) softened butter • ¾ level tsp baking powder • Finely grated zest of ½ lemon •

ICING

• 50g (2oz) granulated sugar • Juice of ½ lemon •

1. Preheat your oven to 180°C/350°F/Gas Mark 4.
2. Mix together all the cake ingredients in one bowl until combined, then pour into a greased 1lb (450g) loaf tin.
3. Bake for about 35 minutes, or until golden brown. If it is cooked, when pressed gently with a finger, the cake should bounce back.
4. Make the lemon drizzle topping while the cake is still warm by mixing together the sugar and lemon juice. Pour it over the warm cake, spreading it evenly over the top.
5. Leave to cool a little, then remove the cake from its tin and enjoy.

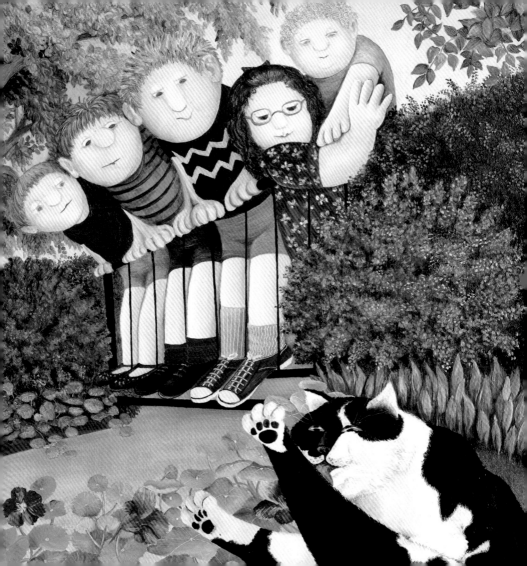

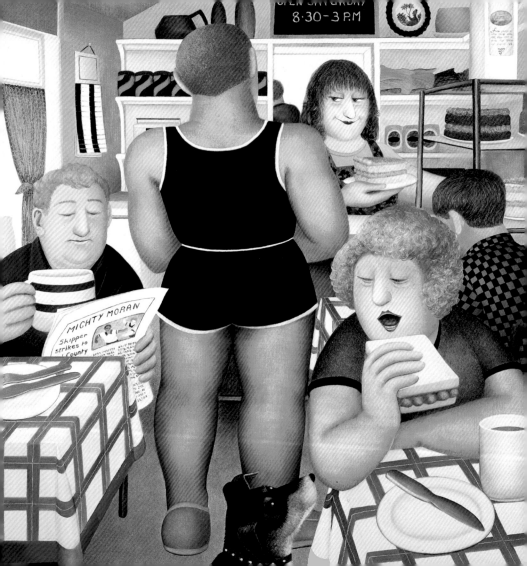

Coffee and Walnut Cake

CAKE
• 225g (8oz) unsalted butter, plus extra for greasing • 225g (8oz) caster sugar • 4 eggs
• 50ml (2fl oz) strong instant coffee (or espresso) • 225g (8oz) self-raising flour • 75g (2¾oz) walnuts •

BUTTERCREAM TOPPING
• 125g (4½oz) unsalted butter • 200g (7oz) icing sugar • 50ml (2fl oz) strong instant coffee
(or espresso) • 12 walnut halves, to decorate •

1. Preheat your oven to 180°C/350°F/Gas Mark 4. Oil and line two 8inch (20cm) tins.
2. In a bowl, beat the butter and sugar together until very light and pale. Add the eggs one at a time, beating well and ensuring the mixture is combined before adding the next egg.
3. Add the instant coffee or espresso, flour and walnuts to the mixture and stir well, until completely combined. Spoon the mixture into the cake tins and bake 25–30 minutes, or until a toothpick will come out clean if inserted into the centre. Remove the cakes from the oven and leave to cool.
4. For the buttercream topping, beat the butter and icing sugar together in a small bowl until pale and light. Add the instant coffee or espresso and mix well. Spread the buttercream over the top of each cooled cake and sandwich together. Decorate the top with the walnut halves and serve with a lovely cup of coffee.

Carrot Cake

CAKE
• 175g (6oz) light muscovado sugar • 175ml sunflower oil • 3 eggs, beaten • 140g (5oz) grated carrots (about 3 medium) • 100g (3½oz) raisins • Zest of 1 large orange • 175g (6oz) self-raising flour • 1 tsp bicarbonate of soda • 1 tsp ground cinnamon • ½ tsp grated nutmeg •

ICING
• 175g (6oz) icing sugar • 1½–2 tbsp orange juice •

1. Preheat your oven to 180°C/350°F/Gas Mark 4 and line the base and sides of a deep 7 inch (18cm) cake tin with baking parchment.
2. Tip the sugar into a large mixing bowl, pour in the oil and add the eggs. Mix together before adding the grated carrots, raisins and orange rind. In a separate bowl, mix the flour, bicarbonate of soda and spices, then sift into the egg and sugar mixture. Mix until combined (the mixture itself should be soft and almost runny).
3. Pour the mixture into the prepared tin and bake for 40–45 minutes. You will know it is cooked when it bounces back if pressed lightly with a finger. Cool in the tin for 5 minutes, then turn it out, peel off the paper and cool for a little longer, then slice it into two layers.
4. Mix the icing sugar and orange juice together until smooth and spread lavishly over the tops of the cake halves and sandwich them together.

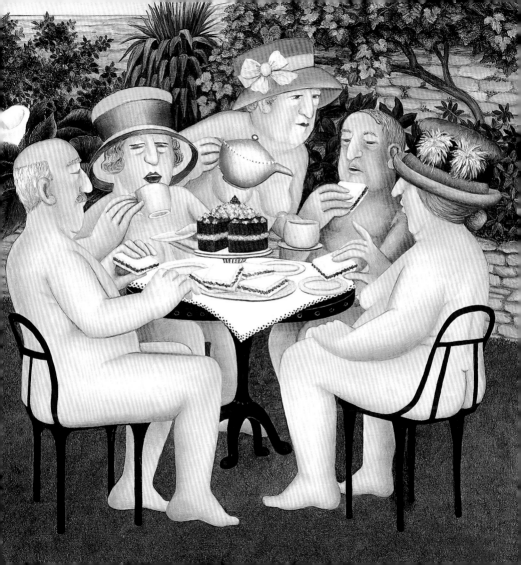

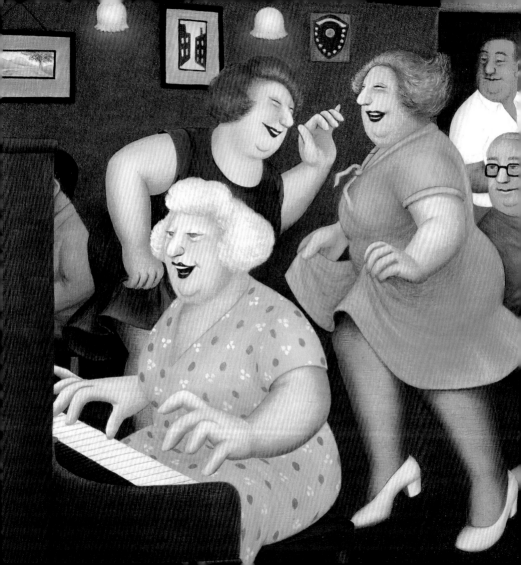

Chocolate Espresso Cake

CAKE

- 185g (6½oz) butter, softened • 185g (6½oz) dark chocolate • 340g (11¾oz) caster sugar
- 3 eggs • 140g (5oz) ground almonds • 200g (7oz) self-raising flour
- 250ml (9fl oz) hot strong espresso, sweetened with 2 tbsp caster sugar •

1. Preheat your oven to 180°C/350°F/Gas Mark 4. Lightly oil and line an 8 inch (20cm) tin.
2. Gently heat the butter and chocolate over a low heat and stir until melted. In a different bowl, beat together the sugar and eggs until pale and thick and then quickly fold into the chocolate mixture. Add the ground almonds and flour and mix until smooth.
3. Spoon the mixture into the prepared cake tin and bake in the oven for 50 minutes to one hour, or until just firm.
4. When cooked, leave to cool for roughly 20 minutes before removing from the tin. Meanwhile, place the sweetened espresso coffee into a saucepan, bring to the boil and simmer for a minute until syrupy.
5. Serve the warm cake with a spoonful of whipped cream and a drizzle of the hot espresso sauce.

Pineapple Upside-down Cake

CAKE

• 7–8 pineapple rings (depending on arrangement), drained • 100g (3½oz) sugar
• 100g (3½oz) butter • 2 eggs • 100g (3½oz) self-raising flour • 6 tbsp golden syrup
• 2 tbsp water • Glacé cherries (to decorate) •

1. Preheat your oven to 190°C/375°F/Gas Mark 5.
2. Oil a 7 inch (18cm) round cake tin and arrange the pineapple rings in the bottom of it.
3. Cream the sugar and butter together in a bowl and beat in the eggs. Fold in the flour and pour in the golden syrup.
4. Pour the sponge mixture on top of the pineapple design, and bake for 20–30 minutes or until golden brown and cooked through. You can check this by using a toothpick to test the centre of the cake, and if it comes out clean, the cake it cooked.
5. After the cake has cooled thoroughly, carefully tip it out of its tin upside-down onto a serving plate. Use glacé cherries in the centre of the rings in order to achieve the full retro aesthetic.

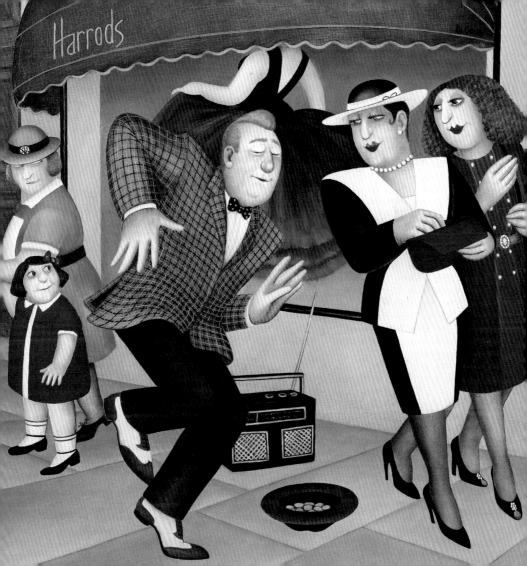

Lemon Polenta Cake

CAKE

• 175g (6oz) unsalted butter • 175g (6oz) caster sugar • 100g (3½oz) ground almonds
• 100g (3½oz) self raising flour • 3 large eggs • Zest from 4 unwaxed lemons • Juice of 1 lemon
• 115g (4oz) polenta • 1 tsp baking powder • Pinch of salt •

1. Preheat your oven to 160°C/325°F/Gas Mark 3. Lightly oil and line an 8 inch (20cm) tin.
2. Mix all of the ingredients together in a large mixing bowl or food processor until smooth.
3. Pour the mixture into the tin and bake for 45–50 minutes or until a toothpick will come out clean if inserted into the centre.
4. Leave the cake to cool before serving. While you wait, contemplate how something that appears so plain will taste so utterly delicious.

Lavender and Honey Cake

CAKE

- 225g (8oz) unsalted butter • 115g (4oz) sugar • 115g (4oz) honey (lavender honey if you have it)
- 3 eggs • 245g (8½oz) all-purpose flour • 1 tsp baking powder • ½ tsp baking soda • ½ tsp salt
- ½ tsp cinnamon • ½ tsp chopped dried lavender, plus more for garnish • 110ml (3¾fl oz) sour cream •

GLAZE

- 4 tsp lemon juice (one lemon should provide enough) • 2 tsp of honey • 100g (3½oz) Icing sugar •

1. Preheat your oven to 170°C/325°F/Gas Mark 3. Oil and line a 9 inch (23cm) cake tin.
2. Cream the butter, sugar and honey together until light and fluffy. Beat the eggs lightly and incorporate into the butter mixture. Mix the dry ingredients together in a separate bowl and stir well. Start adding the flour mixture and the sour cream alternately and a bit at a time until all ingredients are combined.
3. Pour the mixture into your prepared cake tin and bake for about 50 minutes, or until a toothpick will come out clean if inserted into the centre.
4. While the cake is cooling, whisk the lemon juice and honey together and then stir in the sifted icing sugar. Drizzle over the cake and sprinkle with additional lavender to decorate.

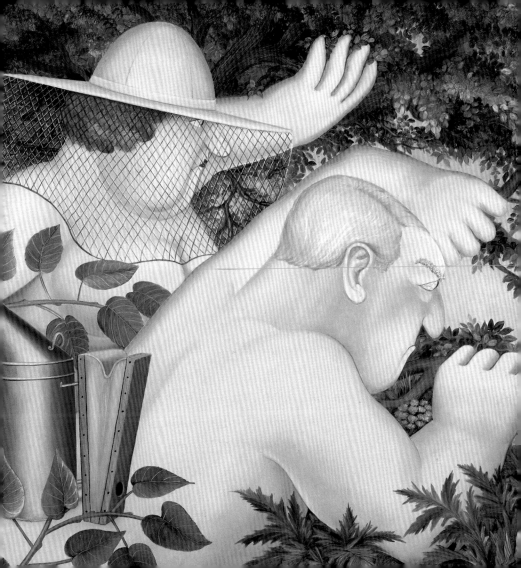

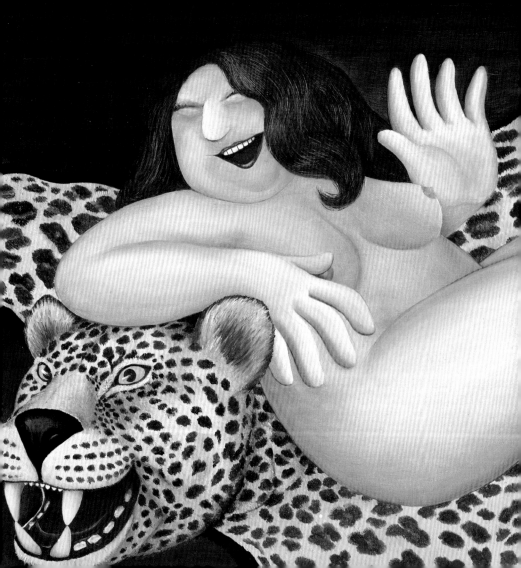

Easy Chocolate Cake

CAKE
• 3 large eggs • 175g (6oz) self-raising flour • 175g (6oz) caster sugar • 175g (6oz) softened butter • 1½ level tsp baking powder • 40g (1½oz) cocoa powder • 4 tbsp boiling water •

ICING
• 150ml (5floz) double cream • 150g (5oz) plain chocolate, broken into pieces •

1. Preheat your oven to 180°C/350°F/Gas Mark 4. Oil and line two 8 inch (20cm) tins.
2. Beat together the eggs, flour, caster sugar, butter and baking powder in a large mixing bowl until smooth. Put the cocoa in separate mixing bowl, and add the water a little at a time so that it forms a paste. Add to the cake mixture and stir until combined.
3. Pour into the prepared tins, and bake for about 20–25 mins, or until it bounces back if prodded lightly. Leave to cool in the tin for ten minutes, then turn out and leave to cool completely.
4. For the icing, mix the cream and chocolate in a bowl and carefully melt over a pan of hot water on a low heat. Stir until melted, then set aside to cool and to thicken up. When both the cake and icing are cool, spread half of the icing over one of the cakes, then lay the other cake on top, sandwiching them together. Spread the rest of the icing on top. Enjoy in generous proportions.

Apple Cake

CAKE

• 100g (3½oz) butter • 150g (5¼oz) caster sugar • 2 eggs
• 100g (3½oz) buttermilk • 1 tsp vanilla extract • 200g (7oz) flour
• 1 ½ tsp baking powder • 2-3 apples, depending on size, peeled and chopped •

1. Preheat your oven to 180°C/350°F/Gas Mark 4. Oil and line an 8 inch (20cm) tin.
2. Melt the butter and then whisk in the eggs and sugar until frothy.
3. Stir in the buttermilk and vanilla extract followed by the flour and baking powder.
4. Pour the mixture into the prepared tin. Evenly scatter the apple pieces (apples with a more tart flavour will provide an added apple zing to your creation) into the mixture. Bake for about 45–50 minutes, or until a toothpick will come out clean if inserted into the centre.
5. Leave to cool and enjoy with dollops of vanilla ice cream (optional but recommended).

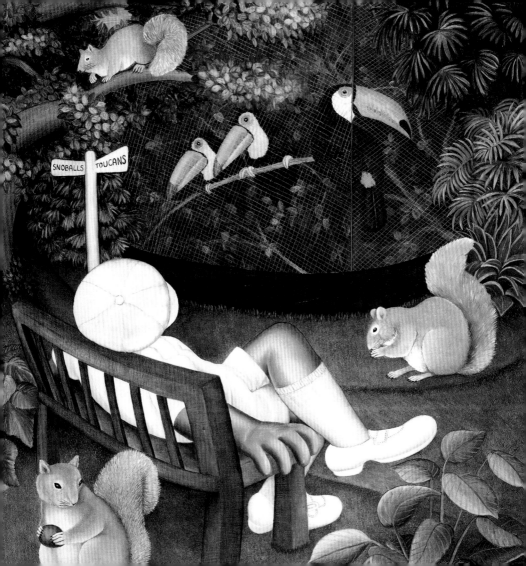

Chocolate Éclairs

CHOUX PASTRY (MAKES 12 ÉCLAIRS)
• 75g (2½ oz) plain flour • 150ml (5fl oz) water • 50g (1¾ oz) butter • 2 eggs, beaten •

FILLING
• 300ml (10fl oz) whipped cream •

ICING
• 100g (3½ oz) plain dark chocolate • 100ml (3½ fl oz) double cream •

1. Preheat your oven to 220°C/425°F/Gas Mark 7. Grease a large baking tray.
2. Put the butter and water into a saucepan and bring to the boil.
3. Tip in all the flour and then remove from the heat and stir quickly together until you have a paste. Put the pan back on the heat and stir until you have a doughy ball.
4. Remove the mixture from the heat again and start stirring in the beaten eggs, little by little. Keep going until you have a nice glossy mixture.
5. Using a 1cm (½in) plain nozzle, pipe the mixture into twelve 3 inch (7.5cm) lengths. Leave space around them as they will expand in the oven.
6. Bake for 10 minutes before reducing the heat to 190C/375F/Gas 5 and baking for a further 20 minutes. Make a slit lengthways down each éclair and leave them to cool.
7. To make the icing, break the chocolate into pieces and put it in a bowl with the cream over a pan of simmering water. Stir until combined and leave to cool and thicken.
8. Fill the cooled éclairs with the whipped cream and then spoon on the icing.

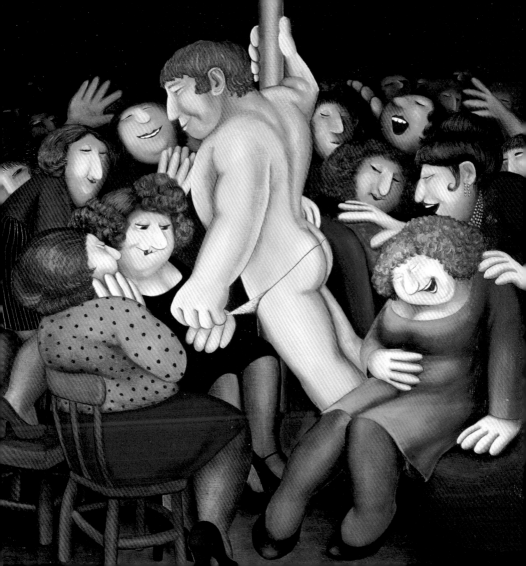

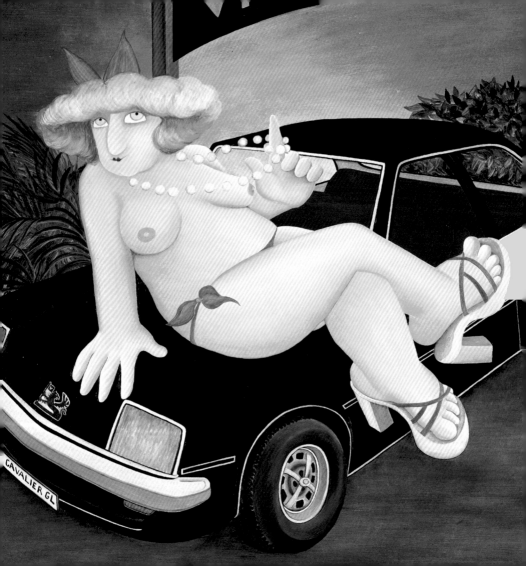

Saucy Scones

SCONES
• 150g (5½oz) self-raising flour, plus extra for dusting • 2 tbsp caster sugar • ½ tsp baking powder
• 2 tbsp milk, or enough to bind • 2 tbsp butter, melted • 25g (1oz) butter •

SAUCE
• 1 apple, cored and sliced • 25g (1oz) butter • 2 tbsp brown sugar
• ½ tsp cinnamon • 1 lemon, zest and juice only •

1. Preheat your oven to 180°C/350°F/Gas Mark 4. Line a large baking tray with baking parchment.
2. Put the flour, sugar and baking powder into a bowl and mix until combined. Whilst still mixing, pour in the milk and melted butter, adding more milk if necessary to bring together a ball of dough.
3. Turn the dough out onto a floured work surface and shape into a ball. Flatten the ball slightly, and cut into wedges. Heat the remaining butter in an ovenproof frying pan, add the scone wedges and fry for a minute or two on each side, or until they begin to colour. Transfer to the oven to cook for six to eight minutes, or until golden-brown.
4. For the sauce, place all of the ingredients into a pan and cook for a few minutes, or until the apples are very tender. Then mash vigorously with a fork.
5. Serve the scones with a good dollop of the apple sauce and (if you're feeling particularly indulgent) some clotted cream.

Triple Chocolate Brownies

- 275g (10oz) plain chocolate • 275g (10oz) unsalted butter • 85g (3oz) pecans, broken into pieces
- 85g (3oz) milk chocolate, cut into large chunks • 85g (3oz) white chocolate, cut into large chunks
- 175g (6oz) plain flour • 1 tsp baking powder • 4 large eggs, lightly beaten
- 1 tsp vanilla essence • 325g (12oz) caster sugar •

1. Preheat your oven to 170°C/325°F/Gas Mark 3. Line a 9 inch (24cm) baking tin with lightly buttered greaseproof paper.
2. Sieve the flour and baking powder into a bowl and set aside.
3. Put the plain chocolate and butter in a large bowl, place over a pan of simmering water and melt. Remove the melted chocolate from the heat and stir in the sugar. Add the eggs and vanilla essence. Fold in the flour, nuts and remaining chocolate pieces.
4. Pour the mixture into the prepared cake tin. Place in the oven and bake for 20–25 minutes. Although the top will be cooked, the centre should remain slightly gooey (it will turn solid when it cools), so allow the brownie cool in the tin. When cool, cut into squares and enjoy.

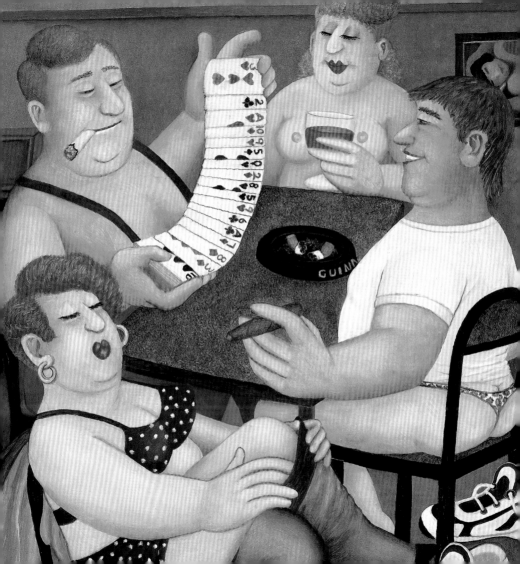

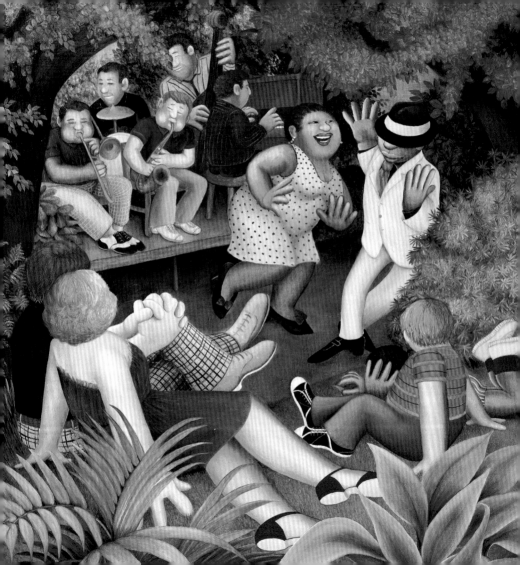

Apricot and White Chocolate Flapjacks

• 200g (7oz) dried apricots, finely choppped • 225g (8oz) salted butter, cubed
• 120g (4¼oz) light brown muscovado sugar • 150g (5¼oz) runny honey • 1 lemon, zest only
• 2 tbsp treacle • 400g (14oz) rolled oats • 200g (7oz) white chocolate for topping •

1. Preheat your oven to 180°C/350°F/Gas Mark 4. Oil and line an 8 inch (20cm) square tin.
2. Put the butter, sugar and honey in a saucepan over a medium heat and stir until melted and well mixed. Add the apricot pieces, lemon zest and treacle and mix until combined.
3. Tip in the oats and stir until it forms a rather mushy ball of mixture.
4. Put into the prepared tin and spread evenly.
5. Bake for 20–25 minutes, or until golden brown. Remove from the oven and allow to cool completely before turning out from the tin and slicing into pieces.
6. Melt the white chocolate in a heatproof bowl over a pan of barely simmering water. Either dunk one end of each flapjack into the melted chocolate or drizzle melted chocolate over the top – or both!

Macaroons

- 125g (4½oz) icing sugar • 125g (4½oz) ground almonds
- 90g (3½oz) egg whites (3–4 eggs) • 2 tbsp water • 110g (4oz) caster sugar
- 150ml (5fl oz) double cream, whipped •

1. Preheat your oven to 170°C/325°F/Gas Mark 3 and line a large tray with baking paper.
2. Put the icing sugar, ground almonds and 40g (1½oz) egg whites together in a large bowl and mix to a paste. Put the water and caster sugar in a small pan and heat gently to melt the sugar, then turn up the heat and boil until the mixture starts to go syrupy and thicken.
3. Whisk the remaining 50g (2oz) egg whites in a small bowl until medium-stiff peaks form, then slowly pour in the sugar syrup, whisking until the mixture becomes stiff and shiny. Combine the two mixtures, stirring gently. For coloured macaroons, add a few drops of food colouring.
4. Pipe or dollop 4cm/1½ inch flat circles onto the lined tray and flatten gently with a slightly wet finger, if necessary. Leave them to stand for 30 minutes so that they form a skin, then bake in the oven for 12–15 minutes until firm.
5. When cool, sandwich the macaroons together with whipped cream.

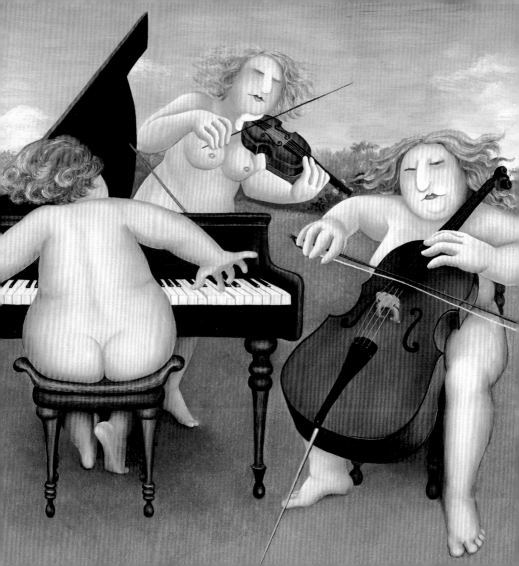

Maple Syrup & Bacon Cupcakes

CAKES
- 170g (6oz) butter • 215g (7½oz) caster sugar • 180g (6½oz) flour • 1 tsp baking powder
- ½ tsp salt • ½ tsp grated fresh nutmeg • Pinch of cinnamon • 125ml (4½fl oz) whole milk
- 3 eggs, separated •

ICING
- 60g (2oz) butter • 300g (10½oz) icing sugar • 1 tsp vanilla essence
- 125ml (4½fl oz) double cream • 4 tbsp good maple syrup •

TOPPING
- 4–5 slices of bacon, cooked until crispy • Extra maple syrup for glaze • Toasted pecans •

1. Preheat your oven 180°C/350°F/Gas Mark 4. Set out paper cases on a baking tray.
2. Cream together the butter and sugar until light and fluffy. Add the yolks one at a time, beating until thoroughly blended. Then add the dry ingredients – the flour, spices, baking powder and salt – in three parts, alternating with milk. Beat the egg whites until stiff and gently fold them into the mixture. Divide the batter evenly into the cupcake casess and bake for 15 minutes or until just brown. Leave to cool.
3. To make the icing, beat the butter until soft. Add the sugar, vanilla and cream, then add the maple syrup, beating until smooth and creamy.
4. Pipe the icing onto the cooled cupcakes, then add a toasted pecan and a strip or two of crispy bacon to each. Glaze with a little more maple syrup and enjoy the sweetest breakfast ever!

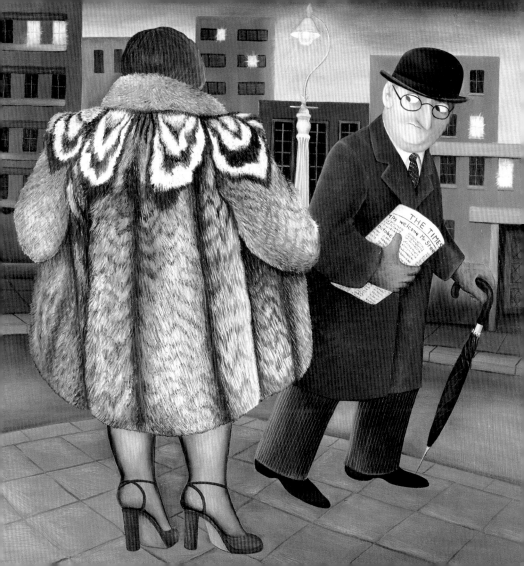

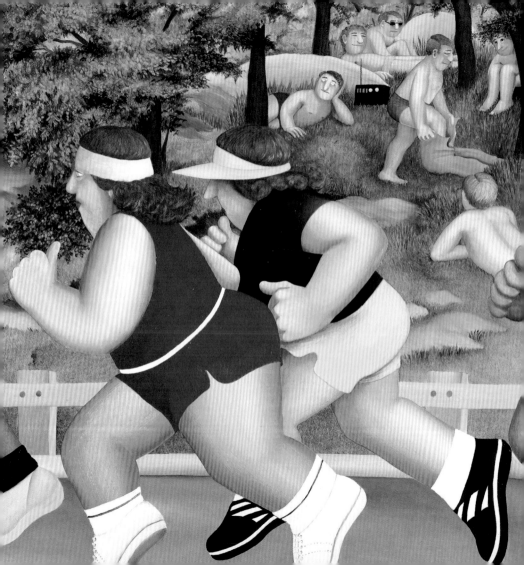

Devil's Food Cupcakes

CAKE

• 180ml (6¼fl oz) boiling water • 75g (2½oz) cocoa powder • 170g (6oz) butter • 400g (14oz) sugar • 1 tsp fine salt • 1 tsp vanilla essence • 3 eggs • 275g (9¾oz) flour • 1 tsp bicarbonate of soda • 1 tsp baking powder • 240ml (8½fl oz) buttermilk •

GANACHE

• 230g (8oz) chocolate pieces • 180ml (6¼fl oz) double cream • 2 tbsp sugar • 2 tbsp butter •

1. Preheat your oven to 180°C/350°F/Gas Mark 4. Set out paper cases on a baking tray.
2. Whisk together the boiling water and cocoa and set aside. Cream together the butter, sugar, salt and vanilla essence. Add the eggs, one at a time, and continue creaming until light and fluffy. Sift together the flour, bicarbonate of soda and baking powder and add this mixture, alternately with the buttermilk. Add the cocoa and water mixture and stir until thoroughly combined.
3. Divide the batter evenly into the cupcake cases and bake for 20–25 minutes, until a toothpick can be inserted and removed clean. Leave to cool.
4. Place the chocolate in a stainless steel or glass bowl. Put the cream and sugar into a saucepan and bring to a boil. Pour the mixture over the chocolate. Whisk together and then stir in the butter until melted.
5. Leave the ganache to set and then pipe or spread it onto the cupcakes. A mini mouthful of indulgence for any occasion!

Chocolate Orange Cupcakes

CAKES

• 120g (4oz) plain flour • 140g (5oz) caster sugar • 1 tsp baking power • 40g (1½oz) unsalted butter • 50g (2oz) dark chocolate, melted • 1 egg • 125ml (4fl oz) milk • 1 orange, juice only • 3 tbsp granulated sugar •

BUTTERCREAM TOPPING

• 125g (4½oz) unsalted butter, softened • 250g (9oz) icing sugar • 2–3 tbsp milk • 50g (1¾oz) white chocolate, melted • 1 orange, zest only • 100g (3½oz) orange chocolate •

1. Preheat your oven to 170°C/325°F/Gas Mark 3. Set out paper cases on a baking tray.
2. Mix the flour, sugar and baking powder together, then add the butter and stir until combined. Meanwhile, whisk the melted dark chocolate, egg and milk together in a jug. Stir this chocolate mixture into the flour mixture until just combined. Spoon into the cases and bake for 15–20 minutes, or until risen and golden-brown. Remove from the oven and set aside to cool for a few minutes.
3. Meanwhile, mix the orange juice and granulated sugar together in a bowl. Carefully pour the orange juice mixture over the warm cakes and set aside to cool completely.
4. For the buttercream topping, beat the butter until light and fluffy. Stir in the icing sugar and continue to beat until combined. Mix in the milk, melted white chocolate and orange zest. Pipe or spread on the buttercream and grate some chocolate onto the top to add the finishing touch.

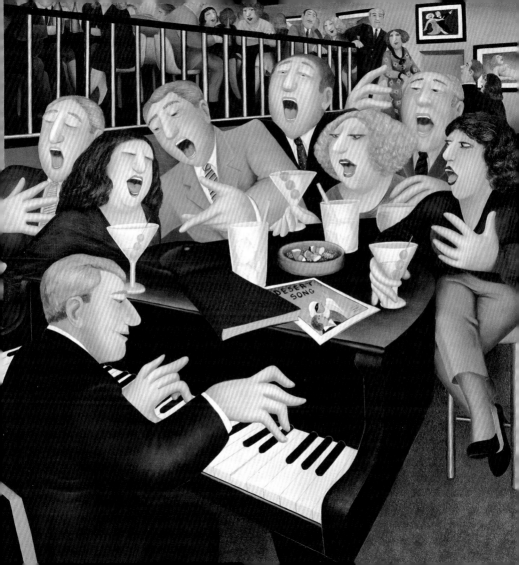

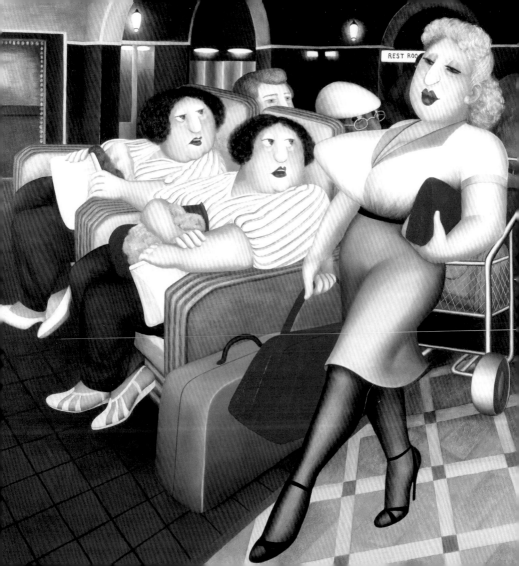

Gingerbread Cupcakes

CAKES

• 150g (5¼oz) butter • 150g (5¼oz) soft brown sugar • 3 eggs • 150g (5¼oz) self-raising flour
• 1 tsp ground ginger • ½ tsp ground cinnamon • Pinch freshly grated nutmeg • 1 tbsp milk •

FROSTING

• 200g (7oz) butter, at room temperature • 50g (1¾oz) soft brown sugar
• 3 tbsp milk • 200g (7oz) icing sugar • Pinch ground cinnamon •

1. Preheat your oven to 180°C/350°F/Gas Mark 4. Set out paper cases on a baking tray.
2. Cream together the butter and sugar until light and fluffy. Sift the flour together with the spices. Gradually mix the eggs into the creamed butter and sugar, alternating with the flour. Finally, incorporate the milk. Divide the mixture between the cases and bake for 15–20 minutes or until golden. Remove from the oven and cool.
3. While they cool, place 50g of the butter in a pan with the brown sugar and cook over a low heat until melted. Add two tbsp of the milk and stir to form a thick glossy toffee sauce. Leave to one side to cool to room temperature.
4. In a large mixing bowl, beat the butter until smooth then start to sift in the icing sugar, stirring regularly. Add the toffee sauce and stir until thoroughly incorporated. Add a splash more milk if the mixture seems too thick.
5. Pipe or spread the frosting onto the cupcakes and sprinkle with ground cinnamon.

Strawberries & Cream Cupakes

• 200g (7oz) unsalted butter, softened • 200g (7oz) caster sugar • 4 eggs • 200g (7oz) self-raising flour
• 4 tbsp good-quality strawberry jam • 250ml (9fl oz) lightly whipped double cream
• 250g (9oz) strawberries, hulled • Icing sugar, for dusting •

1. Preheat your oven to 180°C/350°F/Gas mark 4. Set out paper cases on a
 baking tray.
2. Cream the butter and sugar together in a large bowl until the mixture is light and fluffy.
 Beat in the eggs, one at a time, until well combined. Fold in the remaining flour until
 you have a soft, smooth mixture. Spoon the mixture into the paper cases until half full,
 add half a tsp of jam and then cover with the remaining cake mixture. The finished cake
 case should be about three-quarters full. Bake in the oven for 15–18 minutes, or until
 the cakes are pale golden-brown and bounce back when pressed lightly with a finger.
 Remove the cakes from the oven and set aside to cool.
3. Using a small knife, make a well in the top of each cake and fill with whipped
 cream. Top with a strawberry, then serve with a generous dusting of icing sugar
 on a summer's day.

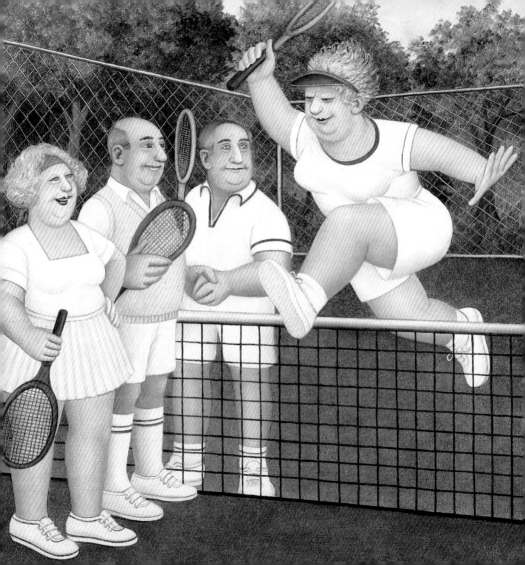

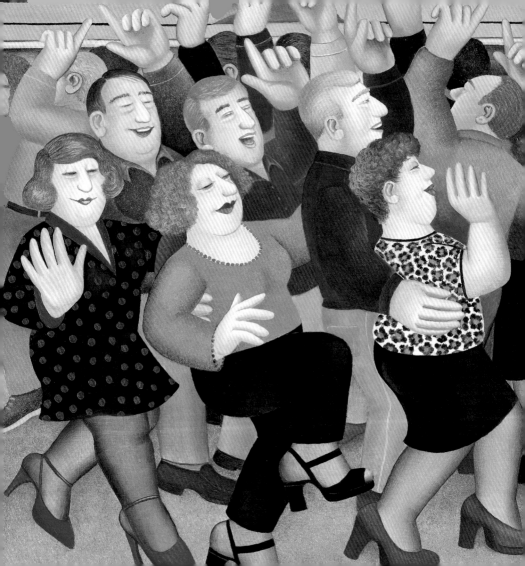

Gooseberry Cupcakes

CAKES

• 225g (8oz) self-raising flour • 1 tsp baking powder • 200g (7oz) golden caster sugar
• 3 eggs • 150g (5¼oz) natural yogurt • 4 tbsp elderflower cordial
• 175g (6oz) butter, melted and cooled •

FOOL TOPPING

• 330g (11½oz) gooseberries, topped and tailed, or use frozen • 50g (1¾oz) golden caster sugar
• 1 tbsp elderflower cordial • 200g (700g) crème fraîche •

1. Preheat your oven to 180°C/350°F/Gas mark 4. Set out paper cases on a baking tray.
2. Mix the dry ingredients together in a large bowl. In another bowl, beat the eggs, yogurt, elderflower cordial and melted butter together with a pinch of salt, then stir into the dry ingredients. Spoon generously into the cases and bake for 18–20 minutes until golden, then leave to cool.
3. Meanwhile, put the gooseberries and the sugar into a frying pan, then gently cook for ten minutes until the berries have softened, but a little bit of bite remains. Taste for sweetness, then stir in the elderflower cordial and allow to cool. Once completely cool, fold into the crème fraîche.
4. Next, cut a section out of the top of each cake. Spoon a dessertspoonful or so of the fool into each cake, and top with the piece that you cut away to create a dreamy summer treat.

Black Forest Cupcakes

CAKES

• 100g (3½oz) butter, softened • 100g (3½oz) caster sugar • 85g (3¼oz) self-raising flour
• 15g (½oz) cocoa • 2 eggs • 1 tsp vanilla extract •

BUTTERCREAM TOPPING

• 300g (11oz) British cherries, stalks and stones removed, fruit halved • 2 tbsp caster sugar
• 6 tbsp water • 1½ tsp cornflour • 100g (3½oz) butter, at room temperature • 200g (7oz) icing sugar
• 1 tbsp semi skimmed milk • 1 tsp vanilla extract • 3 tbsp Kirsch •

1. Preheat your oven to 180°C/350°F/Gas Mark 4. Set out paper cases on a baking tray.
2. Put all the cake ingredients in a bowl and beat until smooth. Divide the mixture between the cake cases and smooth the tops. Bake for 15 minutes or until the tops bounce back when pressed with a fingertip. Leave to cool completely.
3. Next, put the cherries, sugar and five tbsp of water in a saucepan over a low-medium heat. Simmer for five minutes until the cherries release their juices. Mix the cornflour with 1 tbsp of water and stir it into the cherry mixture. Increase the heat for a further two to three minutes, stirring until the sauce has thickened. Leave to cool.
4. Meanwhile, beat the butter with half the icing sugar until smooth, then gradually add the remaining sugar, milk and vanilla extract, beating continuously.
5. Using a fork, poke a few holes in the top of each cake and drizzle over the kirsch. Pipe a swirl of buttercream on each cake and top with the cherry mixture.

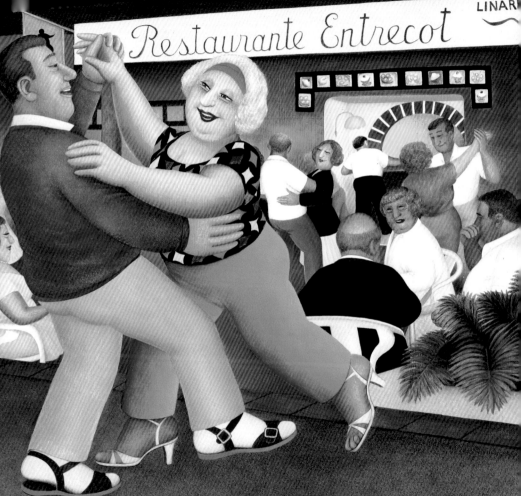

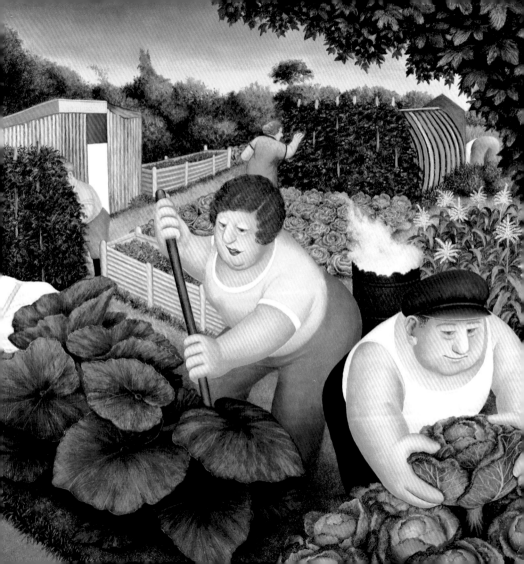

Rhubarb & Custard Tart

- 375g (13oz) ready-rolled sweet short crust pastry
- 800g (1¾lb) rhubarb, trimmed and cut into 4–5cm (1½-2in) pieces
- 340g (11½oz) golden caster sugar • 1 vanilla pod, split • 1 tbsp corn flour
- 2 large eggs (beaten) plus 1 egg white • 1 x 300ml pot crème fraîche •

1. Preheat oven to 200°C/400°F/Gas mark 6 and grease a 9 inch (23cm) tin with a removable base. Roll out the pastry to about a quarter of an inch (0.5cm), line your tin, prick the base with a fork and put it in the fridge to chill.

2. Place the rhubarb in an ovenproof dish with 120g (4oz) of the sugar and the split vanilla pod. Bake it for around 20 minutes. It should be tender but still holding its shape. Discard any liquid and leave it to cool. Keep the seeds from the vanilla pod for later.

3. Line the chilled pastry base with cooking parchment and fill with baking beans. Bake for 15 minutes, then remove the beans and return to the oven for five to ten minutes. When cooked (but still pale) remove from the oven and seal by brushing with egg white. Turn down the oven temperature to 170°C, 325°F, Gas Mark 3.

4. Mix together the rest of the sugar with the corn flour and gradually whisk in the eggs, crème fraîche and vanilla seeds. Arrange the cooled rhubarb pieces on the pastry case and cover them in the custard. Bake for about 30 minutes until set in the middle – give it a little jiggle to test. See if you can wait for it to cool before you dig in!

Chocolate Tart

- 375g (13oz) ready-rolled sweet short crust pastry
- 400g (14oz) dark chocolate, finely chopped • 150ml (5¼fl oz) full fat milk
- 250ml (8¾fl oz) whipping cream • 2 eggs, lightly beaten •

1. Preheat the oven to 220°C/425°F/Gas Mark 7 and grease a 10 inch (26cm) tin with a removable base. Roll out the pastry to about a quarter of an inch (0.5cm), line your tin, prick the base with a fork and put it in the fridge to chill.
2. Line the chilled pastry base with cooking parchment and fill with baking beans. Bake for 15 minutes, then remove the beans and return to the oven for five to ten minutes. After this, remove from the oven and leave to cool. Reduce the oven to 120°C/250°F/Gas Mark ½.
3. Tip the chocolate into a heatproof bowl. Bring the milk and cream to the boil then pour over the chocolate, mixing briskly to form a glossy mixture. Leave to cool slightly and then stir in the eggs until the mixture is beautifully smooth. Pour the chocolate mixture into the tart case and bake for about 30 minutes until set in the middle – give it a little jiggle to test.

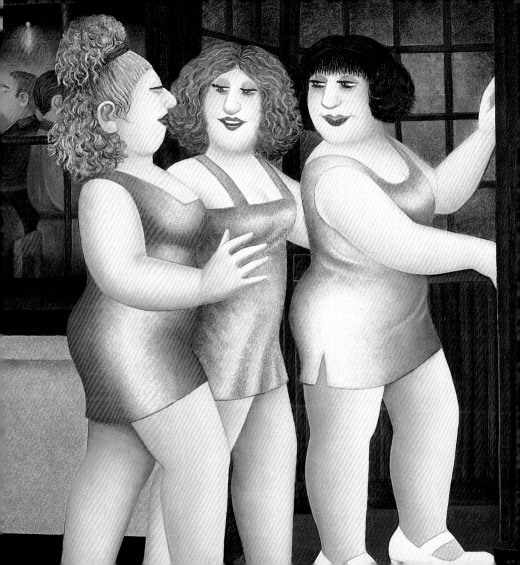

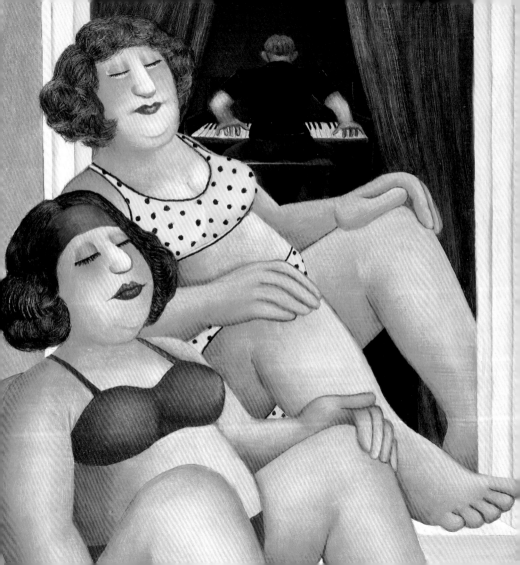

Lemon Tart

• 375g (13oz) ready-rolled sweet short crust pastry
• 3 medium eggs • 100g (3½oz) caster sugar • 142ml carton double cream
• Finely zested rind and juice of 3 lemons • Icing sugar, for dusting •

1. Preheat the oven to 190°C/375°F/Gas Mark 5 and grease a 9 inch (23cm) tin with a removable base. Roll out the pastry to about a quarter of an inch (0.5cm), line your tin, prick the base with a fork and put it in the fridge to chill. Line the chilled pastry base with cooking parchment and fill with baking beans. Bake for 15 minutes, then remove the beans and return to the oven for five to ten minutes. After this, remove from the oven and leave to cool. Reduce the oven to 180°C/350°F/Gas Mark 4.

2. Beat the eggs, then add sugar, cream and lemon rind and juice and mix well. Pour the mixture into the pastry case, filling it almost to the top. Bake the tart in the centre of the oven for 20–30 minutes, or until the edges of the filling have set and it has just a little wobble if shaken. Remove from the oven and leave to cool in the tin for about 20–30 minutes. Chill the tart well, and dust it with icing sugar just before serving.

Summer Fruits Tart

• 375g (13¼oz) crumbled digestive biscuits • 75g (2¾oz) soft unsalted butter • 400g (14oz) cream cheese (at room temperature) • 240g (8½oz) lemon curd (at room temperature)
• 125g (4½oz) blueberries • 125g (4½oz) blackberries • 125g (4½oz) raspberries
• 125g (4½oz) redcurrants (or pomegranate seeds) • 125g (4½oz) small strawberries, chopped •

1. Crush the biscuits to crumbs and combine with the butter to form a crunchy dough. Press this into the sides and bottom of a 10inch (26cm) tart tin and place in the freezer for about 10–15 minutes.
2. In a new bowl, mix the cream cheese and lemon curd together and spread this onto the chilled biscuit base with a spatula.
3. Arrange the fruit artistically on top of the lemony cream cheese and place the tart in the fridge for at least five hours – preferably overnight. It needs to be very cold before being removed from the tin, in order for it to hold together.

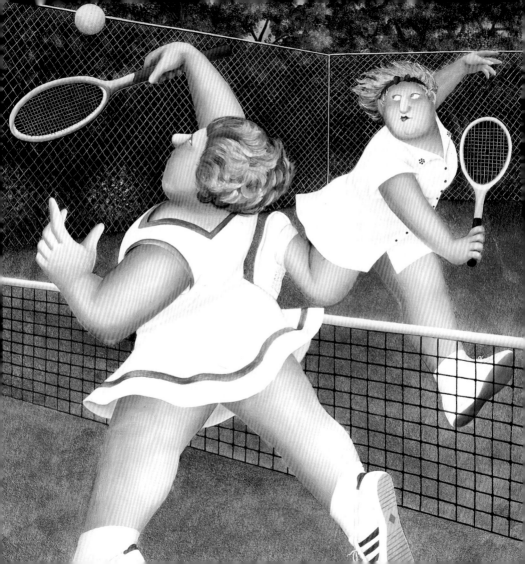

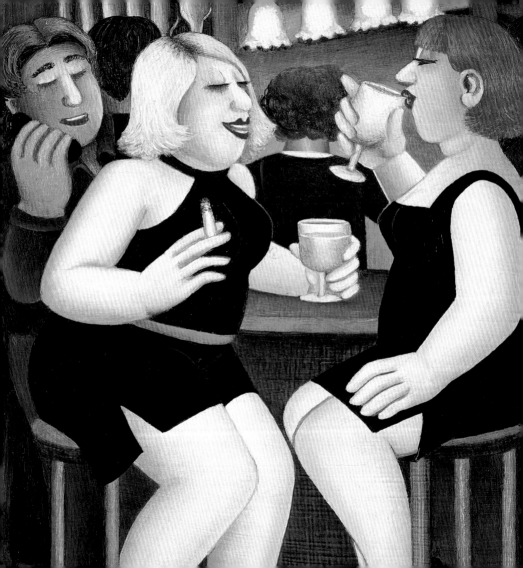

Blueberry Tart

- 375g (13oz) ready-rolled sweet short crust pastry
- butter, for greasing • 1kg (2lb) blueberries • 125g (4oz) caster sugar •

1. Preheat the oven to 180°C/350°F/Gas Mark 4 and grease a 10 inch (26cm) tin with a removable base. Roll out the pastry to about a quarter of an inch (0.5cm), line your tin, prick the base with a fork and put it in the fridge to chill. Line the chilled pastry base with cooking parchment and fill with baking beans. Bake for 15 minutes, then remove the beans and return to the oven for five to ten minutes. After this, remove from the oven and leave to cool. increase the temperature to 200°C/400°F/Gas mark 6.
2. Rinse the blueberries and mix them with the sugar. Pour the mixture into the pastry case and return to the oven for 20 minutes.
3. Remove the tart from the oven and let it cool for 10 minutes before serving.

Chocolate & Peanut Butter Tart

- 375g (13oz) ready-rolled sweet short crust pastry
- 360ml whole milk • ¼ tsp salt • 3 egg yolks • 75g (2¾oz) light brown sugar
- 4 tsp all-purpose flour • 125g (4½oz) creamy peanut butter • ½ tsp pure vanilla extract
- 85g (3oz) chocolate, chopped • 55g (2oz) (¼cup) butter • 1 tbsp golden syrup •

1. Preheat the oven to 180°C/350°F/Gas Mark 4 and grease a loose-bottmed10 inch (26cm) tart tin. Roll out the pastry to about a quarter of an inch (0.5cm), line your tin, prick the base with a fork and put it in the fridge to chill. Line the chilled pastry base with cooking parchment and fill with baking beans. Bake for 15 minutes, then remove the beans and return to the oven for five to ten minutes. After this, remove from the oven and leave to cool.

2. In a saucepan, bring the milk and salt to a simmer over medium heat. Meanwhile, whisk the egg yolks, brown sugar and flour until well blended. Slowly add the hot milk, whisking constantly. Pour the mixture back into the saucepan. Cook over medium heat, stirring constantly, until it thickens and comes to a full boil. Remove the pan from the heat and mix in the peanut butter and vanilla. Pour this into the tart case and chill for at least two hours.

3. Melt the chocolate, butter and corn syrup in a glass bowl over simmering water and whisk until the mixture is smooth. Spread this glaze evenly over the tart and return to the fridge until set – then go nuts!

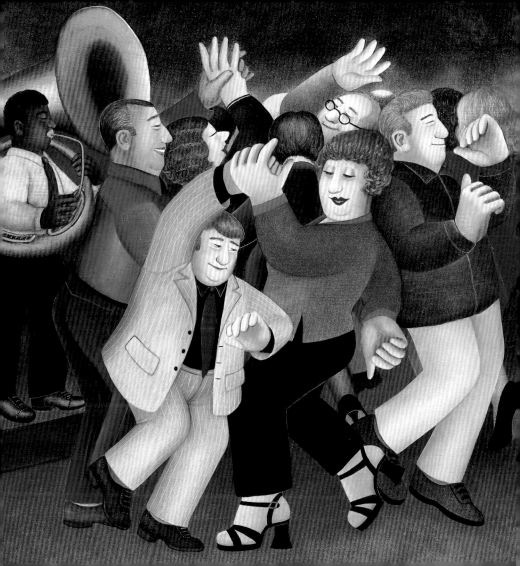

30 Cakes to Eat Naked
Published by Kinkajou
Copyright © 2015 Frances Lincoln Limited

Beryl Cook Illustrations © 2015 John Cook. All rights reserved.
Licensed by Iris, www.thisisiris.co.uk

A catalogue record for this book is available from the British Library.

Designed by Sarah Allberrey
Background texture © TairA/Shutterstock
Decorative frame © babayuka/Shutterstock
Decorative line element © Lena Pan/Shutterstock

Kinkajou is an imprint of Frances Lincoln Limited
74–77 White Lion Street
London N1 9PF
www.kinkajou.com

ISBN: 978-0-7112-3737-7
Printed in China

9 8 7 6 5 4

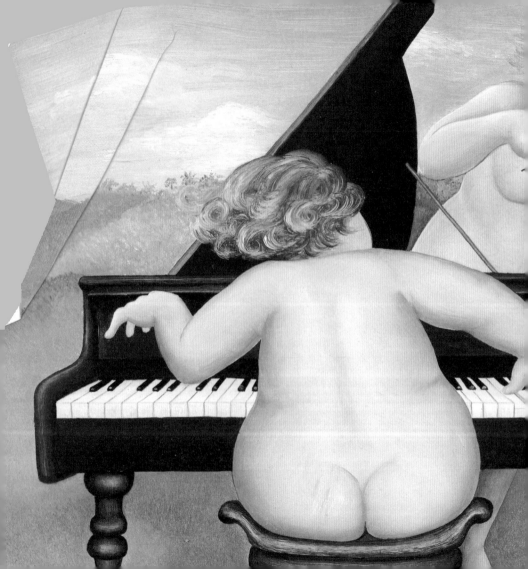